ORIENTAL
BRUSHWORK

ORIENTAL
BRUSHWORK

ORIENTAL BRUSHWORK

BY WANG CHI-YUAN

with Ruth Martin

濟遠寫

PITMAN PUBLISHING CORPORATION

New York • Toronto • London

THE CONTENTS

THE ILLUSTRATIONS

All paintings and studies are by Wang Chi-Yuan

ORIENTAL BRUSHWORK

ABOUT THIS BOOK

You are interested in Oriental Brushwork, and having chosen this book to study, your natural question is: "Can I learn to paint Chinese pictures?"

The answer must be: No.

There are no materials, methods, or instructions that can make you paint Chinese pictures. Of course you can copy and possibly arrive at amazingly accurate imitations, but there is actually very little satisfaction in this form of pretense.

Neither will you find here ways, means, and shortcuts to become a dauber or a dashing abstractionist. The medium which you are studying is one demanding discipline—discipline first of yourself, then of your tools. This is a way of painting whose nature is considered, subtle, mature; it is not stilted or over-precise. It does not have the casual freedom which is license and absence of either taste or control.

You will notice that we seem to speak most of *Chinese* painting. This does not mean that Japanese painting, or Korean, or *anything* else is excluded. It does mean going back to the roots, to the original spirit and purpose of painting in the Far East, and this phase of art had its source in China. Water-ink painting belongs to us all; it is not only Oriental. It can express the modern ideals of America and all the West, just as it has told of the finest traditions of the East.

The things that did happen during those thousands of years and through the work of thousands of people have their immediate use for you in demonstrating over and over that the act of painting, the *total experience* of preparation, performance, and practice is of as great importance to your development as an artist and a person as is the production of a visible piece of work.

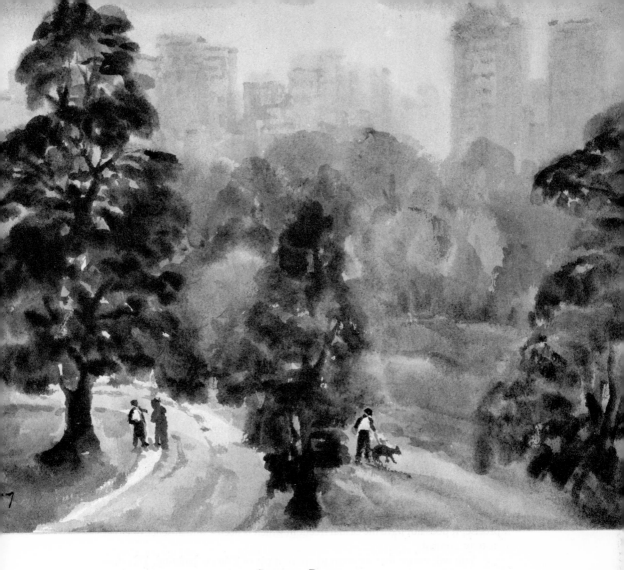

CENTRAL PARK.

You, an individual, a person who wants to paint, seek direct help in working, but there appear no made-to-order diagrams to illustrate particular points of technique. To include these would give you a series of "practice" pictures, but only at the price of depriving you of the beauty and satisfaction which lies in complete visual works.

The caption accompanying each illustration indicates particular elements of method or technique. The experiences and reactions of the artist in these works you may neither share nor borrow. But you can learn, as he did, to use the same kind of tools to record your own particular pleasures.

An important point is one of approach. You find here the ideas and thinking of an experienced painter—one who has been working a long time; yet he seems to speak almost too simply, in everyday language. This is not a matter of talking down to you, of assuming you represent only an uncertain or beginner's talent. It is the only way you can begin to work with important and long-established truths, when there cannot be talk back and forth and exchange of ideas. The aim is that you not misunderstand anything that is said. Students at the School of Chinese Brushwork, which Wang Chi-Yuan heads in New York, have seen the manuscript and say it is written in the way he talks to them in class and which they have found helpful.

If pleasure is emphasized, it is as part and parcel of accomplishment and satisfaction, not of pastime and amusement. The joy of painting, of making and living with works of art, is part of the joy of living, and this joy is a basic, human, personal right. It comes as an indirect result of serious effort, at least to those who work willingly and intelligently.

You read almost wholly of looking and seeing, of ways of studying—and are given no way of painting a specific thing. There is no pattern to follow anywhere, because we believe that you are creative and do not need a method or routine. If you are seeking keys to that which you already know and feel, keys which will enable you to express your ideas and emotions, which will free your appreciation and latent talent, you can find them here.

R. M.

MATERIALS OF WATER-INK PAINTING

THE BRUSH

Everyone paints with his hand, left or right, and with the first three of his five fingers. It is what the artist does with those fingers that distinguishes his work as an artist, and sets him apart from musicians and mechanics and others who work with their hands.

The Chinese brush is itself an important part of the act of painting, both in its strength and in its flexibility. When brand-new it seems stiff and hard but after a brief soaking in water it becomes soft and flexible, coming to a fine point when drawn out of the water or ink.

Some brushes are made from the wool of old sheep which has been often wet and redried so that the curl is gone but the fibres are strong yet flexible. Other brushes are of deer or fox sable fibres, which have resilience.

From the wide range of brushes to be found, choose perhaps three at first and later six or seven, from a fine one for line work to one large enough for leaves and branches.

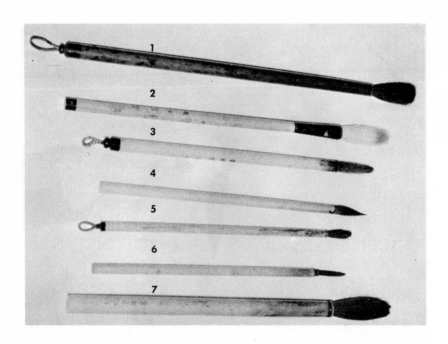

Brushes 1 and 2 are used for shadows and flat tones; 3 for heavy outlines of leaves or branches; 4 is good for drawing blossoms and details; 5 for the same kind of work but for heavier line or tone; 6 is for fine line; and 7 is for broad strokes, shading, water, mountains, and large areas.

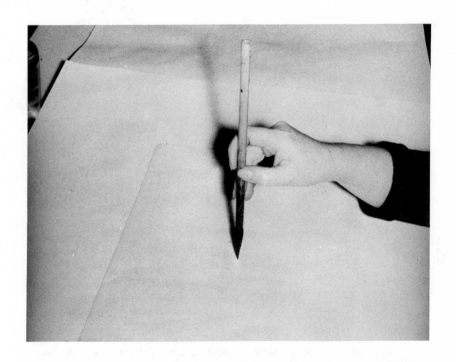

To hold the brush properly, the palm should be open and relaxed, fingers firm but not rigid. Successful use is a matter of practice, practice, and more practice.

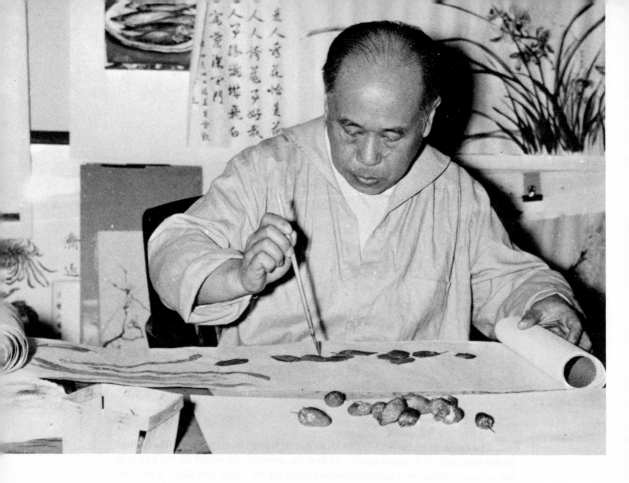

Work sitting at a low table, or holding a portfolio flat on your knees. A pad of paper, which may be newsprint or, as in China, made of felt, provides a firm cushion for the single sheet on which you work. It also absorbs any ink which goes through the paper.

The brush must be held firmly so as not to waver, but it must be free enough under that control to move easily. At first the arm may be rested on the opposite fist, as on a pillow, to raise the painting hand off the paper and allow it to move freely. Later, as control improves, you should work comfortably when both hand and arm are raised slightly above the drawing. With increasing sureness the wrist is freed to move with facility, and then the elbow will gradually relax. The longer strokes of branches and landscape demand motion not of the fingers but of the larger arm muscles up to the shoulder, so that eventually you are free to work beyond the dimensions your hand can span. It is this mind-and-muscle coordination under self-discipline that first makes possible and later increases both intellectual and emotional expression.

PAPER

There are many qualities, names, and sizes of rice paper. Most of the best now available is made from rice plant fibre, sometimes combined with cotton; and some good papers are made from hemp.

For practice, a piece about 12″ × 15″ can be used for working out details, for drawing lines of all kinds, and for experimenting with ink tones.

In painting, the long and beautifully proportioned narrow strip is used upright or horizontally for pictures or landscape. It may be 12″ or 15″ wide and as long as your taste and your drawing model demand.

Upright rectangles may be used singly, or you may put three or four together for a large composition. These rectangles are ordinarily 15″ or 18″ wide and 30″ or 36″ long. The large sheets are 25″ × 50″ or 36″ × 60″.

These are only some of the suitable sizes. Starting with them you will have a variety to experiment with and from which to make your own choice. Look at the proportions of the paintings illustrated for ideas.

If good quality rice paper is not immediately available, any absorbent paper you can find is suitable for practice work. It may be newsprint, or drawing quality—any unglazed paper at all which produces the effect you want and with which you like to work.

INK STONES AND INK STICKS

The ink stone functions as your palette in calligraphy and water-ink painting. Stones are available in many sizes and kinds but are always of a natural material, never synthetic. Choose one which is of fine-grained stone and about four by five inches in size.

The old and aristocratic stones are made from the rocks found in the riverbeds at the feet of high mountains. You may be fortunate enough to find one of these, but the simpler one will suffice. Sturdy and easy to care for, it need only be washed in clear water after use. This will prevent clogging and the accumulation of fragments of dried ink, which, picked up by a brush, can cause smears.

Good ink is not made in a hurry, nor is it made far in advance of working time. It is compounded of clean water and an ink stick, and their careful combination had definite importance. To work well, ink must be smooth, thick, and black without any grainy quality from old, dried ink. It must be heavy enough to make your strongest, clearest black on the paper in one single stroke. It is diluted with clear water to lighten it, but it may never be strengthened, or built up, by repainting.

There are many kinds of ink stick. Some are old and really collector's pieces, some are cheap and worth little. The student should seek out the least expensive stick that produces suitable ink—whether it is cylindrical or oblong-shaped is immaterial.

To make ink takes more time and care than effort. A teaspoon of water, placed on the flat surface of the stone, is enough to start. The tip of the ink stick is rubbed in the water on the stone, always in a circular motion and with easy pressure. The increasing supply of ink is placed in the well of the stone; it is diluted on the flat surface for lighter tones.

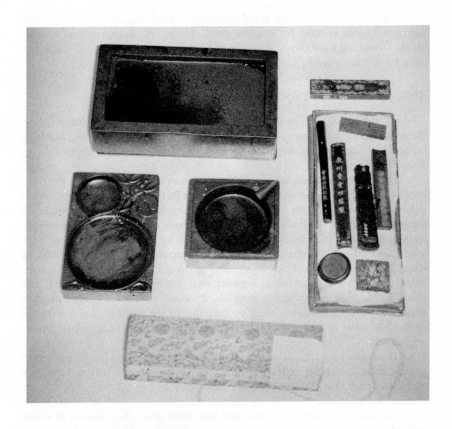

Ink Stones and Sticks. The large stone (top) is an old and fine one. The one with two wells is decorated, and the small one is a student's stone. At right are various ink sticks.

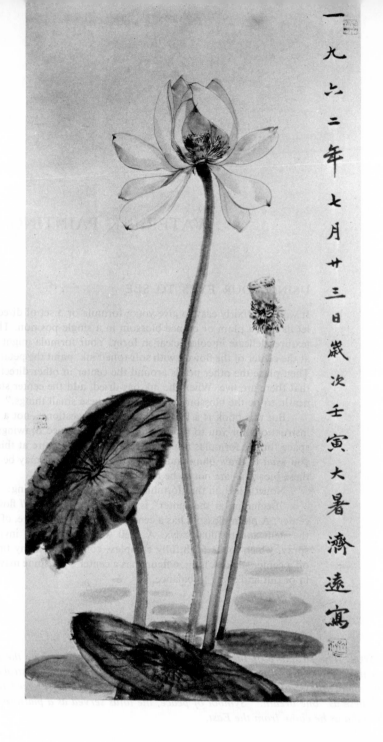

一九六二年七月廿三日歲次壬寅大暑濟遠寫

WATER-INK PAINTING

USING YOUR EYES TO SEE

It would be fairly easy to give you a formula or a set of directions for painting, let us say, a plum or quince blossom in a single position. The flower is soft in texture, delicate in color, clear in form. Your formula might start: "Beginning at the center of the flower, with soft-toned ink, paint the petal facing you—So—. Then place the other petals around the center in other directions, remembering that there are five. When the ink has dried, add the center stamens, and underneath, to tie the blossom to the branch, these small things."

But this book is a book of ideas, of suggestions—not a step-by-step set of instructions for you to reproduce a few stereotyped drawings. We have neither space for the formulas for *all* flowers, nor are we sure at this moment whether you *want* to draw plum and quince blossoms. Or, it may be time of year when these blossoms are not to be found.

Nonetheless, in that formula is your basis for working:

"Beginning at the center" is your beginning for *all* flowers. *Where* is the center? A plum blossom has a center. An apple has a core, of which you can see the stem and residual calyx. A shell winds around an invisible core. A lilac spray, which looks frightfully complex, consists of many tiny florets spiraling off a center stalk. A human figure has a center—the spine may follow it, or curve in or out and away to balance.

LOTUS. *The structure of the leaf, from center to edges, shows how the proportions of the drawing of the leaf are established. The very long stroke of the stem, one stroke, almost straight, strong but not stiff, is referred to in Chinese as "one breath." Symbol of peace, the lotus served as a platform for Buddha as he came from the East.*

NUDE—BACK SKETCH *(collection Mr. and Mrs. Albert R. Kahn). Using a very fluid line, the artist caught the sculptured form of the pose.*

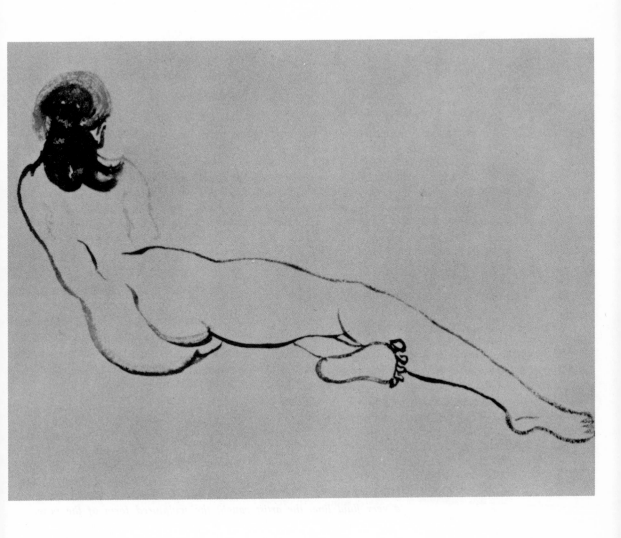

Use your eyes and your sensibilities—find the center of the flower you hold. Look at both its ends and then fix it in your mind before you take the next step. Seen head on, how far is the front from the center? How far is the back? When you tilt it a little, how do the proportions change visually? How long is the right-hand petal? How far does the petal on the left reach out? When you have trained yourself to look for these four dimensions, *draw* the lefthand petal, the right, the front and the back, then those in between, and last those not wholly seen.

The next step of the formula said: "with soft-toned ink." Why? Because the ink must show both *colour* and *texture*. The plum blossom is soft, but a tulip or an anemone is more crisp; the opened bud of a poppy is fuzzy, and the sheath of a lily is dry and crackling. You must look, *touch* with your eyes (which sense almost as do your fingers) to reproduce the feeling.

To practice drawing the flower, begin by placing the center with a tiny dot of ink. In an iris, one petal will go up if it is facing you. It will go *around and up* if it is turned to one side. A flower turned away still has a center. The center of an anemone hanging downward shows that the opened bud springs back from the same center as the petals. Tilt it to one side, then the other, and draw the different shapes—always placing the center and drawing the petals out from it.

When we actually draw from the flower, of course, a single blossom may not be a picture; but a painting of the whole spray, or plant, or branch will still follow the *formula for seeing* that you now know, and you will not have to seek out another book which may give technical instructions for the flower you wish to paint. You will look with your eyes and your senses; you find the center from which the parts open; you establish the color and the texture with the width of your line and the colour of your ink in endless combination. Finally, you make sure that each part of the composition is in proper proportion to its importance and location in the drawing.

GETTING YOUR IDEAS

What to paint is always a problem. It has been a cry with student artists since time began, since no one can create a masterpiece from a Madonna or from a crumpled tin can until there is a personal, *an entirely individual* reaction to the object seen.

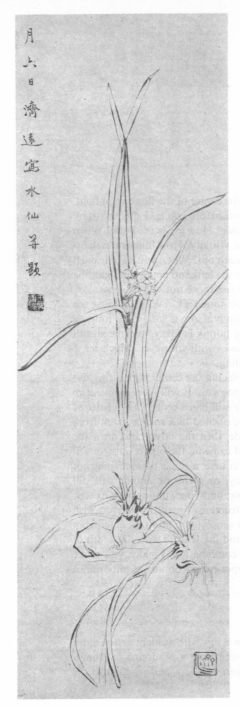

NARCISSUS. *Here is a complete picture drawn from a very simple subject. The bulb is an elementary shape. The long double lines of the leaves indicate the vitality of the plant.*

As a beginning, take something fairly small but something which *pleases* you. Later, when ideas come more readily, you can be selective; for now just *start*. Try a natural shape, a couple of vegetables, or a pair of shells. Then apply your "seeing" formula. For an example, think in your mind's eye of a red pepper and a green one; visualize the difference in colour and translate it into a dark ink and a lighter tone. Set the two peppers down and let them roll a bit to where they settle easily. Do you see the centers or the ends of the cores? Can you show that one side appears shorter because it is turned away; that one side seems heavier because it is turned down in shadow?

This is *seeing*, and this *seeing* is the crux of the personal reaction that is the initial force of creating a picture. Suddenly, the pepper is not a geometric shape, a truncated pyramid. Instead, it is a cluster of segments, or panels, around the center; there is a stem at one end, an indentation at the other.

It may sound somewhat strange to say, "What does a pepper mean to you?" But remember, you are thinking as a painter—look at it again . . . again . . . and again. From "a thing" it becomes "the" thing on which you are now working. Perhaps the colour or combination of colours in some flowers catches your eye. Or you sense the solidity of shape in a melon, or the line of a vine across a wall.

The sum of personal preference, concentration of interest, and continuity of preferred techniques is referred to as "style"—your own personal style.

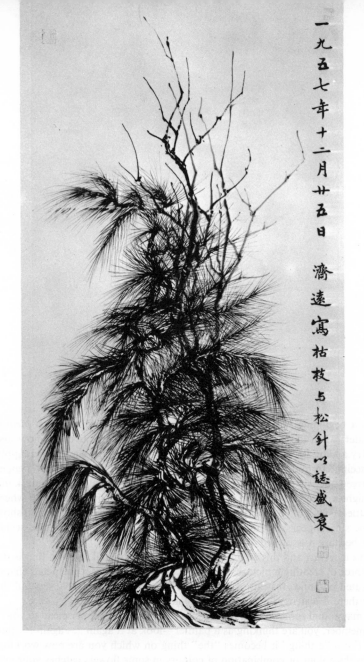

一九五七年十二月廿五日 濟遠寫枯枝与松針以誌盛衰

DEAD BRANCHES AND PINE. *The pine, lush and full of growth, life, and hope, contrasts strongly with the dead branches. Here are shown end and beginning, the new and the old, the full and the spare.*

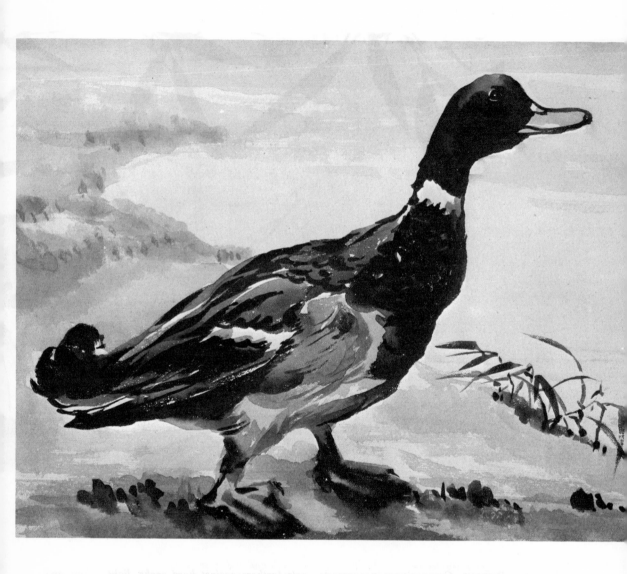

DUCK. *The duck has a long, flexible neck. His feathers are shiny but very soft, sometimes brightly coloured in light, sometimes dull. He is a water creature, shown tied to his element.*

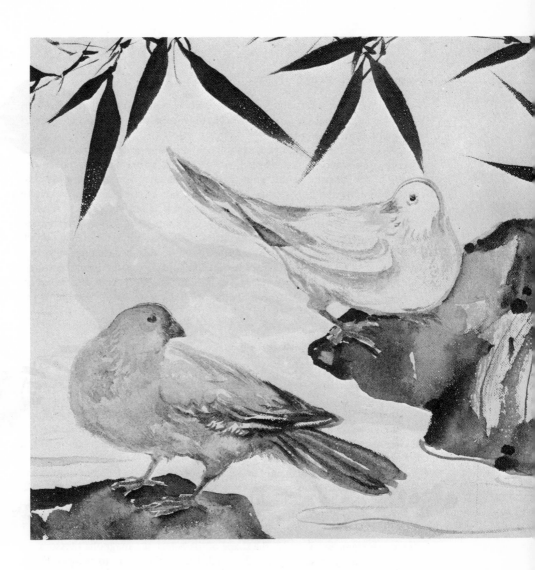

PIGEONS. *Composition in contrasts—soft feathers against hard rocks, light colour and dark, delicate wash against sharp, clean bamboo leaves. Pigeons are a symbol of peace in China; they are tireless in service as communicators.*

EXPRESSING YOUR IDEA

The idea, the impression, which pleases you has no visible life until it is down on paper, for in painting you are endeavoring to transfer your thought, to communicate with more than words.

If a branch looks dry to you, experiment with your brush and ink on a piece of scrap paper until you discover how to make a stroke that shows the dry quality of the branch. At this point in your experience you are showing what nature has done and how it looks, so you need not be concerned with creating and inventing. If the long branch of bamboo has taken your fancy, make it long and keep it looking long. See that you do not draw leaves covering too much of the drawing—see that the idea of length continues to be apparent.

Vivid examples of this point may be found in old Chinese paintings. In a tiger, you may see the eyes enlarged because, should you meet a tiger somewhere face to face, you would be aware of his eyes, huge, bright, seeking. Butterflies are often shown with wings outspread because their shape and color was the reason to paint.

Look . . . feel . . . then paint what is most clear in your reaction.

FORM AND OUTLINE

Form, outline, shape—these are words and abstract ideas until you begin to work.

In the first place, the line, the outline of your subject, the flower or vegetable or vase, looks quite different in different places. It may seem lighter on top and heavier near the bottom. Or it may appear just the opposite in a light which is reflected from a white surface.

Since you are not drawing flat paper shapes, you must indicate volume and depth. You have to *form* your flower or bird; from the two paper dimensions of length and width you have to create the appearance of three dimensions—and do it solely with an ink line. For now, as you read, visualize a large flower of simple shape and hold it in your mind's eye about two feet in front of you on eye level. You can imagine quite clearly the shape of the petals of a magnolia blossom, for instance. Tracing these shapes with an ink line is fairly easy to imagine doing. But here is the problem—you don't want *just* an outline because that would be only a flat pattern. You want a whole, round, living flower. So you visualize again. The front petal is obviously more clear and definite than the back ones.

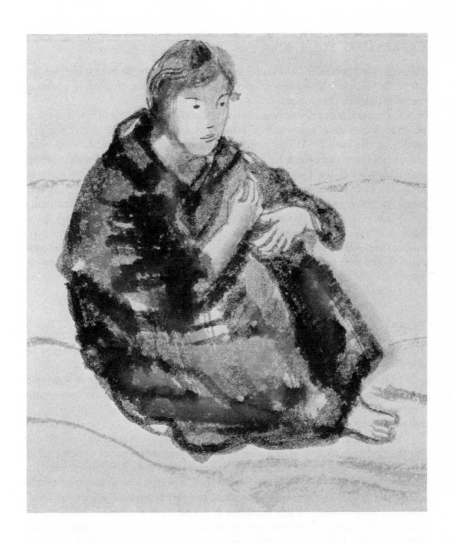

SKETCH OF MODEL RESTING. *Very quickly drawn to catch the brief relaxation—very quiet. The brush was heavily wet with ink and water to show the almost solid form of the model in her relaxed position.*

MISSISSIPPI RIVER AFTER SNOW *(detail of painting).*

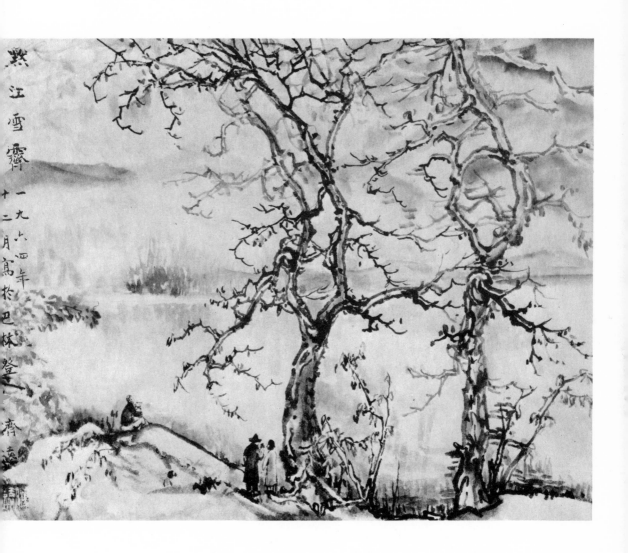

黔江雪霁

一九六四年

十二月写于巴林登 齐远

33

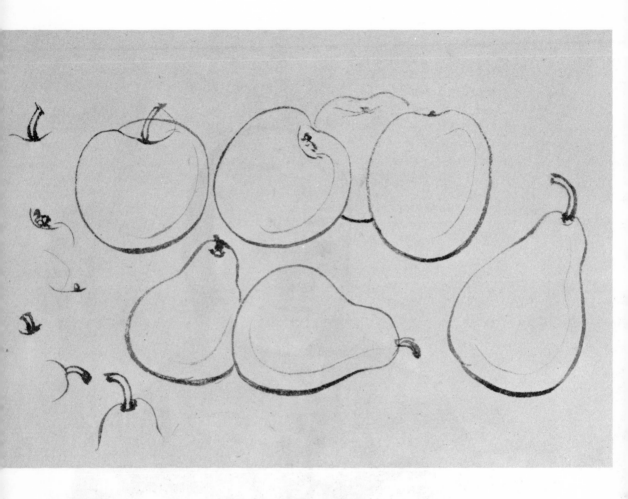

STUDY FOR STILL LIFE. *One continuous line for each fruit shows movement and balance, light and heavy tone.*

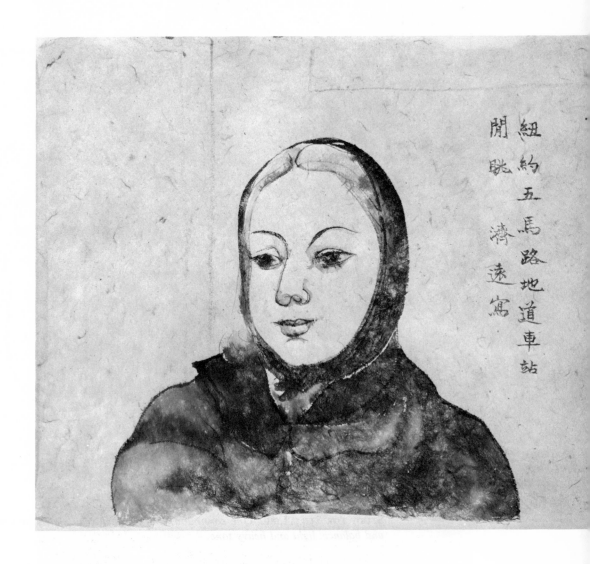

紐約五馬路地道車站

閒眺潑遠寫

SUBWAYS ARE COLD. *Waiting in the station for the train to come, the rider is quiet but alert, muffled against the cold. The form of the head is lightly but clearly outlined in contrast to the heavy coat.*

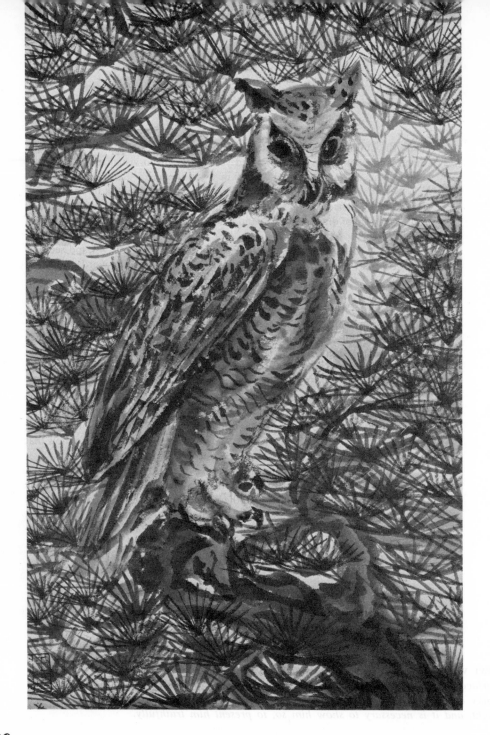

36

Even the outline of the side petals changes as it moves away from the center. Start over again, very carefully—and you will begin to visualize the difference in line. This is exaggerated, but it will give you the idea.

Now try that same careful way of looking when you have a flower at hand. Draw the differences as you see them. After practice you find that you have found your own way of drawing a form and making it different from the flat pattern of outline.

Look at the illustration of the magnolia on pages 48 and 49 and see how the artist has done in ink what we have been discussing in words.

TONE AND TEXTURE OF LINE

In addition to their outer form, all things have substance and texture. You begin to sense very quickly the difference between a soft, silky flower and a crisp, firm bud; you may see that an iris stem is shaped something like a thin iron pipe, but it certainly is not of the same stuff. These are contrasts which must be made as definite as those of soft, light foam falling across hard, sharp edges of rock.

Visualize, for instance, some simple object in two different materials. The top surface of a shiny, light-coloured shape calls for a line very different in quality from the line of the same shape in velvet or fur. The bottom of something like a rock looks, feels, and *is* different, and must therefore be drawn to show that difference.

Make a collection of eight or ten objects—flowers, boxes, birds, branches, a teddy bear. Put them on a neutral cloth background and draw them or imagine drawing them. Look at the texture of the line their forms would need. Move them onto a piece of white paper and see how the texture of the line changes; the box is crisp in outline, the teddy bear almost shaggy. Again, this seems to be exaggerated a little, but when you try, you will be surprised how much more you see.

OWL WITH PINE. *It is possible to make a painting covering almost the whole surface yet making clear definition between the form of the bird and the spiky quality of the pine needles among which he sits. He lives his life at night, and it is necessary to show him so, to present him truthfully.*

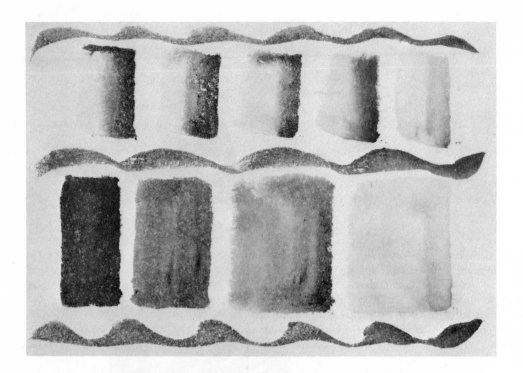

Don't be discouraged, for this is a very easy place to let enthusiasm drag. If you are the kind of person who makes progress sticking to tasks, stick here. If you are better off resting a while, rest here and start again tomorrow. You cannot force a brush to do anything; you cannot make ink draw. Do a little more thinking and your tools will begin to behave.

CHOOSING YOUR COLOURS—IN BLACK AND WHITE

Some things you draw are black and white, some are not. You are about to consider colour, and to produce a colour feeling with only black ink and clear water.

It is not a hopeless task, or even a difficult one, although it may seem involved at first. Just for a moment, think of the *really* difficult problem of painting a white vase standing on white paper and in a bright light. After toying with that in your mind's eye, a brown branch with shell-pink flowers appears now as possibly within your grasp.

38

CAT. *Composed and occupied, the domestic cat is all soft fur over hard bone, skull, and springy muscle. But the alert eye is as alive as that of the jungle tiger who is his close cousin.*

一九五七年八月廿二日 濟遠寫於紐約畫室

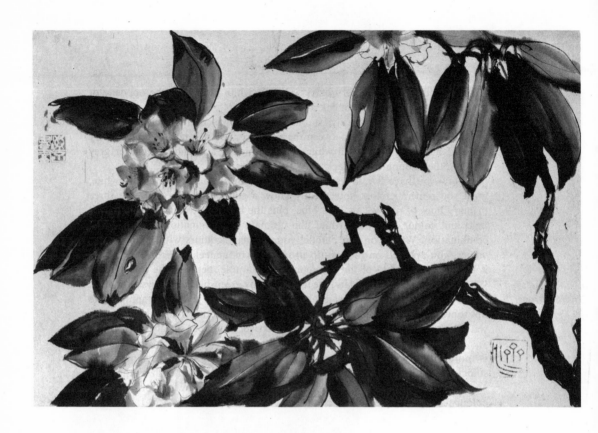

RHODODENDRONS. *The blossoms are distinctly drawn, forming a cluster that is almost a complete sphere. The branches are strong and the leaves spring on short stems in a circle about the line of growth.*

40

Consider your ink: Very black, on your white paper it is the opposite of water that has just a drop of ink added to mark its presence when dried. The extremes of tone are thus easily established. Your own common sense dictates a grey that would be halfway between the extremes, and it is not too much to try to make a light grey between white and the middle, and another, darker grey between the midpoint and black.

Now you have five tones of ink, which are only black, greys, and white, until you remember that you already know a similar scale of five—the three primary hues of red, yellow, and blue, plus the black that is the absence of all light and colour, and pure white, the ultimate of illumination and prismatic combination. When you can parallel your primary colours with your five ink values, you are well on the way to producing colour feeling. From this point, it is your own study—of the difference, for example, between the fresh green-yellow of new willow leaves and the tough, sturdy green-black of chrysanthemum leaves in frosty weather—that enables you to produce your own appropriate ink tones. Next, you can experiment with the subtle tones created by a heavily wet brush or by a fairly dry one quickly run over the paper surface.

Real growth comes when you realize that a blue vase holding green leaves is more blue when placed on white paper, and that at this point you are in sufficient control to show the difference or to alter it when you wish by choice of another background. From here you step off into the rainbowland of colour, of colour feeling, and pleasure in colour—all open to you.

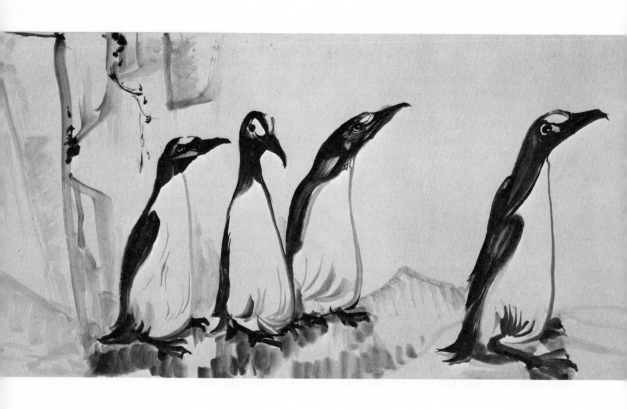

PENGUINS. *Very simple line makes the outline extremely clear, to show the white of the bird in the white of the world around him. He and his companions walk in a line, like soldiers; but their eyes are on different things.*

WHAT LIES BEHIND GOOD PAINTING

THE FACES OF CHANGE

Whether or not you have paid much conscious attention to the idea, you have grown increasingly aware that painting is very much an activity of mind, of mental effort, of continuous observation, consideration, and selection. One of the many things of which you are now more aware is what, for what of a better word, we must call *change*.

Change has many faces, and you gradually learn to deal with them all. Some changes are permanent, caused by character, growth, or death; others are fleeting, the result of breathing or altered light.

44

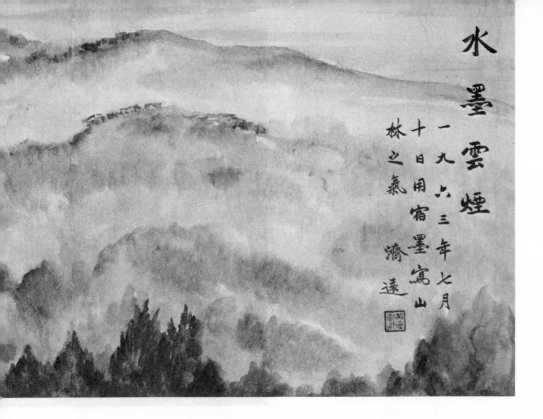

水墨雲煙

一九六三年七月
十日用宿墨寫山
林之氣

濟遠

CLOUD AND MIST IN WATER-INK (*painted in the Pine City of the Philippines*). *Very early morning mist in the valleys hides the mountains. With a wet brush, the artist paints the damp air and the dripping trees which separate the high ridges. This is a very advanced, "high" way of painting.*

When you first started to paint a branch of blossoms, you saw the difference in colour and texture between flower and bark. Now you sense the differences of light on the petals, you find the shadows either sharp or blurred. Leaves may flutter in all directions, or seem fixed and still. The branch which appears one way in the outside light alters its whole colour relationship if you cut it from the tree and place it in a vase. These altered variations—colour of flower, shadow, movement of light, change of location—are only a *few* of the changes you must recognize and for which you must know the reason in order to translate your experience. To draw the outline of a leaf and make it a recognizable leaf-shape is one thing. To draw the leaf and make it a living thing, either in motion or quiet, but alive, is a wholly different accomplishment.

An ice cube is an extreme example. Fresh from the freezer, it is clear, hard of surface, sharply lined, definite against a background. Almost in an instant,

melting water blurs the edges, changes the quality of light shining through, alters and softens and gradually obliterates the shape. You may not be quick enough to catch the changes in a cube, but watch a rose in sunlight from bud to fallen petals. The petals may change neither form nor colour, but they will develop and then relax in both texture and crispness as the flower opens and falls.

PATIENCE AND CONSTANCY

Part of the process of making ink (which has never changed in its long history) is the indirect but definite discipline of removal from other occupation in order to concentrate without interference. There are not many technical problems in the simple making of ink. This patient procedure, this concentration and minor, related, soothing physical activity without any demand from alien sources, is a key facet in all your work.

Although your mind goes to work on the *idea* behind a painting when you start to think about time to paint, you cannot plunge into drawing without thinking through all the aspects of what you are about to do. If you wonder at that, remember you cannot draw the first line of your picture until the ink is made, paper properly laid out to work, and brushes dampened. The mental preparation, making yourself quiet, and being occupied with the beginning steps are demonstrations of plain, old-fashioned patience—and very important.

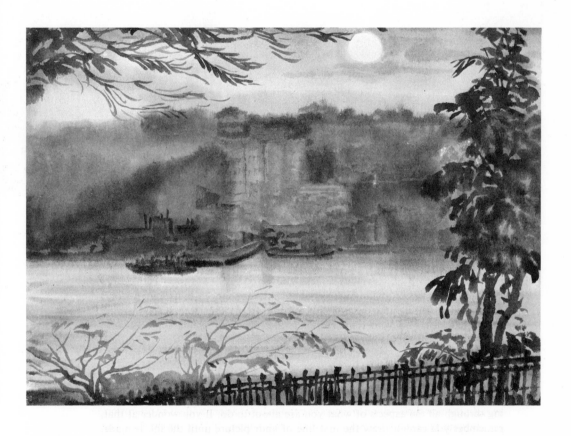

RIVERSIDE DRIVE. *The sun is setting over the New Jersey palisades on a late afternoon; the brilliance of the light is reflected from the clouds onto the river and onto the thinner growth and flexible branches that move up to the fence at the artist's feet.*

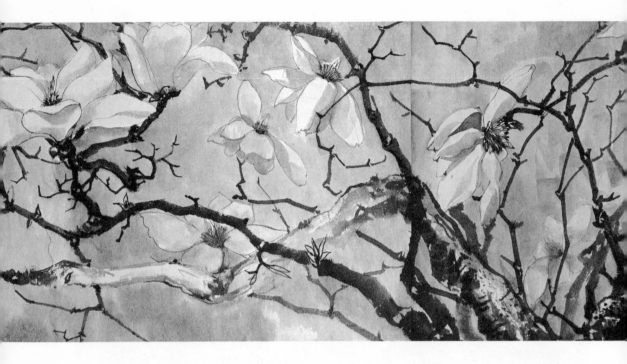

MAGNOLIA *(from a scroll, collection Miss Florence Pasternak). One of the early spring blossoms:*

It is in those seemingly empty moments that you begin to understand what lies behind your work. You know that flowers look different, one from another, but only after quiet thought do you realize how they differ. Of course you know the difference between a sunny day and a cloudy one, but it takes time to remember how the light affects not only the colour of the leaves but the way in which shadows may fall *on* the petals or show *through* them.

Waiting time is the hardest time: it is the thinking time, and the thinking is as difficult as the painting—often more so. But it is necessary to take this time before you begin to work, for water-ink painting is a demanding art. You must be right the first time—not a line can be changed, not a tone will stand alteration.

Beyond patience is constancy, which means being faithful to the idea you

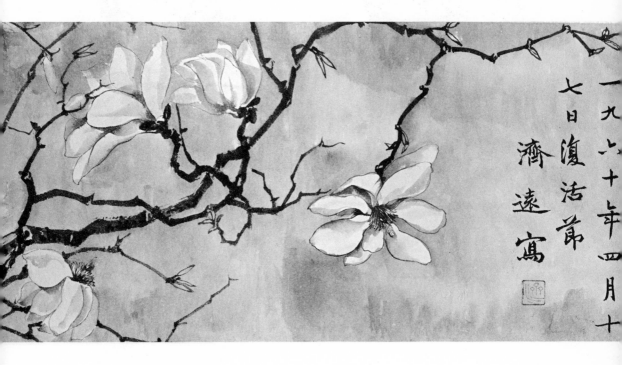

一九六十年四月十七日復活節
濟遠寫

"Light touches a thousand things that grow again."

are pursuing—and being intelligently faithful to that idea. It does not mean repeating effort when that effort does not work. It does mean returning each time to the natural form behind your drawing, rather than working from one drawing to another and repeating impressions or being limited by possible shortcomings in the work.

TIME DOES NOT WAIT FOR THE ARTIST

This talk of preparing, of waiting, of patience, of returning, may seem very hampering when you want to plunge into the fun of working. But deeper than the excitement of painting, than the pleasure of re-creating nature, is the enjoyment

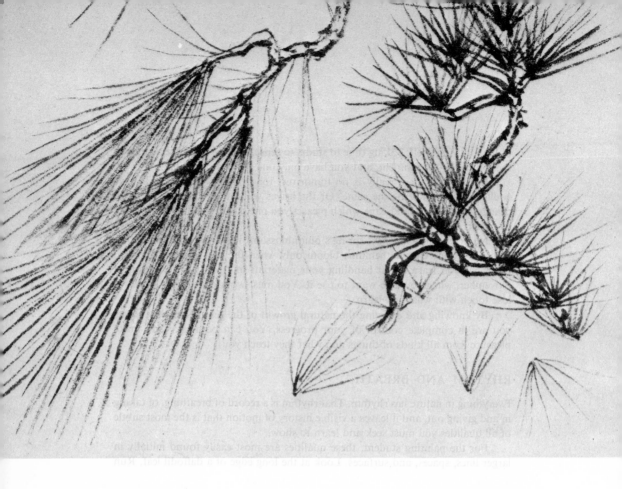

STUDY FOR PINE. *The needles on some pine trees grow upward, on others down-ward. Each cluster of needles is made up of many lines, and each line is distinctly drawn. See* DEAD BRANCHES AND PINE *(page 27) and* OWL WITH PINE *(page 36).*

of life, of living itself. Taking time to study, to sense, to see—these are all part of the full use of the moment, and you have only one moment at a time.

In painting, there really is no tomorrow, for by then the buds will have swelled and will not be the same. Or the leaves will fall and the weather will change, making the landscape which pleases you one day into a dreary place the day after.

No artist can paint next spring's plum blossoms in the September weather of his location; chrysanthemums bloom only when the days start to shorten. But what you learn about handling your materials in April will serve you in November, when you also want to use it. You must work continually, and not lose touch with what you learn.

By knowing and enjoying the natural growth of the seasons as they come, you are in complete control of your progress. You can both take and make pleasure from all kinds of things and what they teach you.

RHYTHM AND BREATH

Everything in nature has rhythm. That rhythm is a record of breathing, of taking in and giving out, and it leaves a visible history of motion that is the most subtle of all qualities you must seek and learn to show.

For the painting student, these qualities are most easily found initially in larger lines, spaces, and surfaces. Look at the long edge of a daffodil leaf. Run

your fingers over it as well as your eyes and you begin to absorb, to realize the tiny variations, the thicks and thins of structure, the silky and the dry places. Touch a plastic replica of a flower and you have no such indications of life and vitality.

Or take a small stone, one you find that has not been cut. In its original state it was fluid and molten; it boiled and stewed. Its surface may be a million years old, but the traces are there, perhaps smooth or gritty, even though the stone is rounded by years of rolling in a stream bed. Again, compare it with cement or clay, which have merely mechanical forms imposed upon them.

Or compare the stone and a melon, two objects which at first glance may appear vaguely similar because both are grey, generally oval-shaped, and have pebbly surfaces. But the melon falls into regular segments; the division may be difficult to see but it is there and reflects the number of petals the melon blossom displayed. The rock has no similar pattern. How could it—it was stirred about and spewed up as a bubble in the heat of the earth's beginning.

TREE PEONY IN BRONZE VASE. *The tree peony* (mou-tan) *is not to be confused with the herbaceous peony,* shao-yao. *The tree is sturdy and long-lived, holding up huge flowers. The petals and center are more decorative than the* shao-yao, *and the leaves are stronger. Mou-tan is a symbol for "rich and noble," indicating by the emphasis that wealth and nobility are combined rarely enough to be remarked when they are.*

52

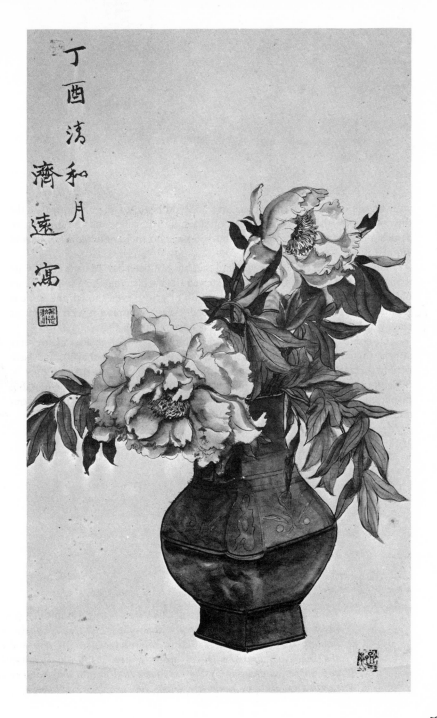

丁酉清和月

齊遠寫

53

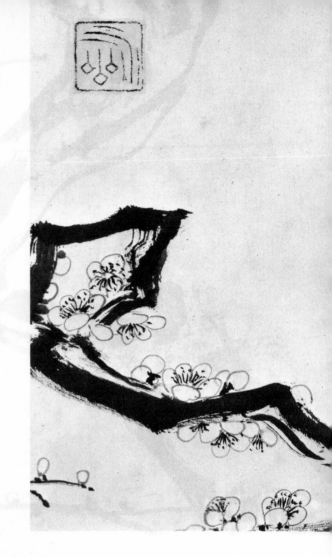

SYMBOLISM

Thinking man has always kept his close relationship to nature, for once divided from the turn of the seasons, the feeling of sunlight and rain, the consciousness of growth and death, he would lose his sense of place in the world about him. Even a sophisticated twentieth-century person senses the inner qualities in trees, in rain, in flowers, in all the mural of the outside world, although he may have created a shell of reticence that makes it awkward for him to speak of them aloud.

54

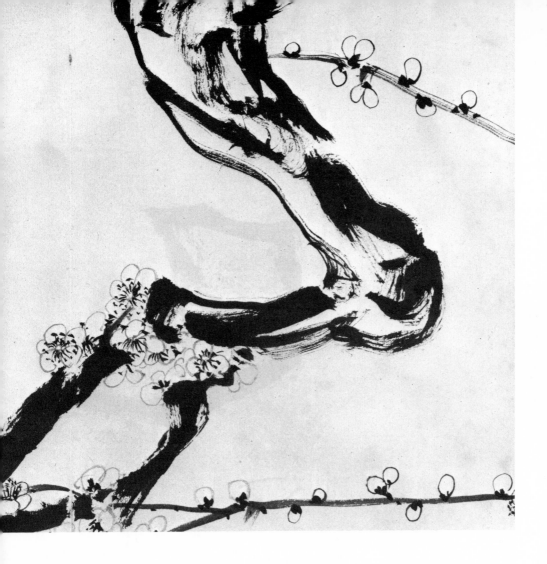

PLUM BLOSSOMS—*detail from Plum Blossom Book (collection Mr. and Mrs. Richard Rymer).*

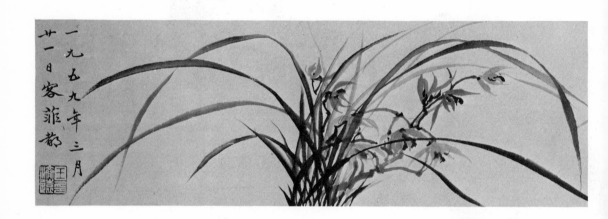

一九五九年三月廿一日客菲都

56

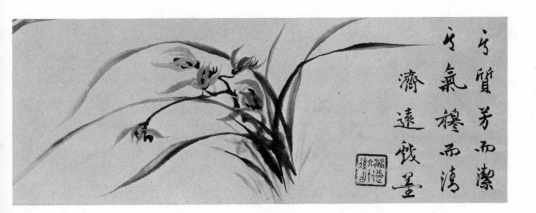

ORCHIDS *(detail from a scroll). The painter says: "The leaves are dancing and the flowers are singing. The quality of the flower is purity." The simplicity of this drawing is balanced by the many tones of ink that appear in the single stroke of the long leaf.*

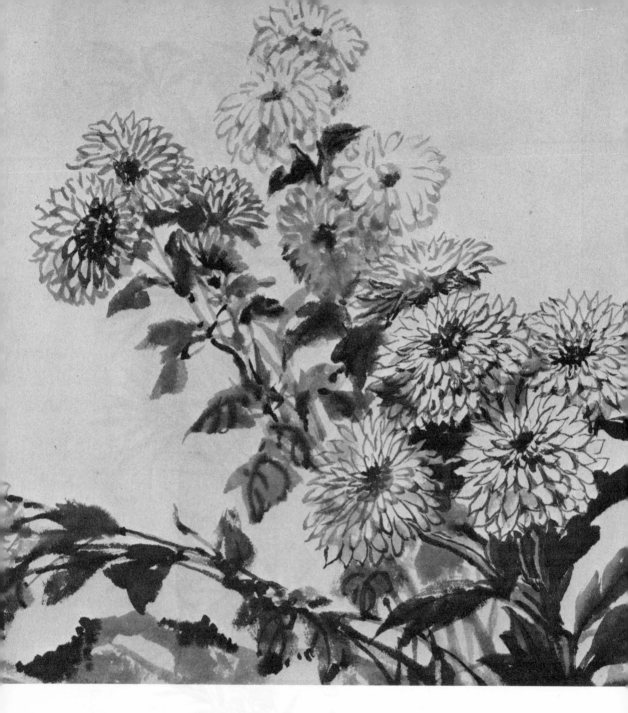

CHRYSANTHEMUM—*detail from scroll (collection Miss Florence Pasternak).*

BAMBOO. *The dark stems and leaves in front are clearly separated in space from the light ones farther back. The leaves grow in groups but each leaf must be separately drawn— groups of leaves are never drawn as groups no matter what the distance. The branches are drawn as they have grown—the lower, older ones are longer, the top, later ones shorter.*

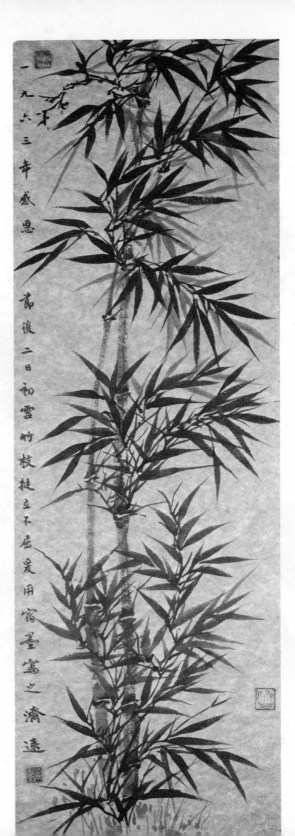

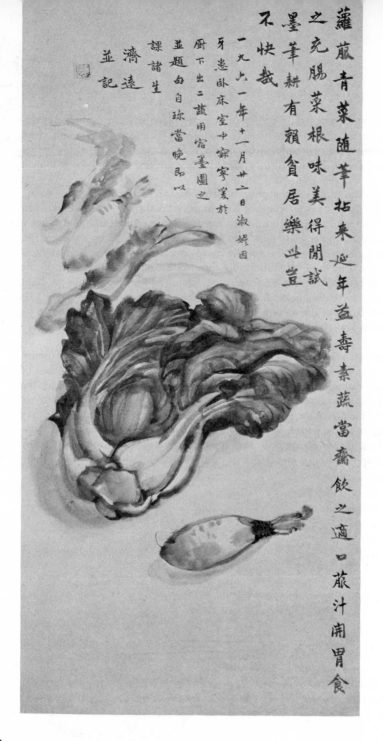

蘿蔔青菜隨筆拈來延年益壽素蔬當齋飲之適口菹汁開胃食

之充腸菜根味美得閒試

墨筆耕有賴貧居樂此豈

不快哉

一九六一年十一月廿二日淑姬因

牙患臥床室中寐寧覓於

廚下出二蔬用宿墨圖之

並題句自珠當晚昂以

課諸生

濟遠

並記

In Oriental painting, four things in nature—plum blossom, orchid, chrysanthemum, and bamboo—epitomize the superior characteristics of strength, clean growth, long life, and graceful structure. Such distinct linkages of man to nature have come down through history because they are tied to permanent human values.

Across the centuries, the plum blossom has become the symbol of spring because the flowers bloom from the bare branches of the tree, and in the coldest weather. Just so do we break out into smiles on a sparkling sunny day after a long, wet, cold winter. The orchid expresses a summer feeling—the colourful blossoms seem to sing and the long leaves to dance on the breeze. The chrysanthemum could be only for autumn, for stronger colours hold their own in the brilliant display of the year, and the sturdy plants and leathery leaves are built to withstand increasing gales. Bamboo ends the year in winter, often holding its leaves in defiance of the ice and snow. It springs back after being held down by heavy drifts, and even when killed by extremes of cold it grows again from the root.

When a Chinese or a Japanese painter is working, he thinks of these things, much as you do. He also thinks of these and of similar symbols as a means of expression, rather than simply as a method of stylized recording. He uses the symbols, as you might, to convey thought, and chooses to paint those things in nature which have the inner qualities upon which he is commenting. He may do honour to an old friend, for example, by a painting of pine branches, for these express long life and strength. In such a painting, the ideas may be expanded by the calligraphy, which is an important part of the composition.

CABBAGE AND WHITE TURNIPS. *The very free drawing of the vegetables was done larger than life and with a large brush full of ink. The black, strictly formed calligraphy completes the composition.*

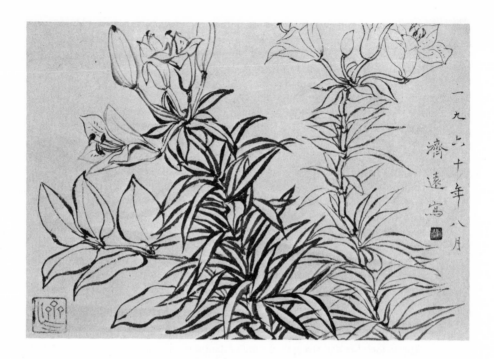

LILY. *Heavy lines are used for the lily stem in front, lighter lines for the one in back. Here you move from the flat pattern of two dimensions into space and the third dimension. The leaves which are equal length, form a circle around the stem, and the petals of the bud are closely wrapped.*

The colour symbols of the Orient reflect rather different values from those of the West, although they seem to agree with the West in aim and desire. In the Western world, yellow has often stood for gold, or the search for gold and wealth. In the East, it also symbolizes a search, but it is the colour of peace. Red is the colour of death, to indicate the spiritual joy of attaining the heavenly state.

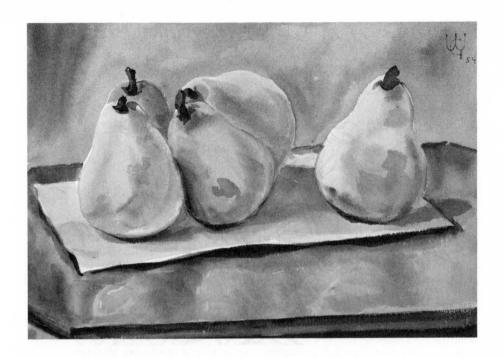

FIVE PEARS. *Shapes so similar might be uninteresting, but they are arranged in such a way that the play of colour and light gives a quality of rhythm, almost of motion. The darker fruit in the center moves toward the back and forms a clear third dimension.*

Blue is hope, and green is harmony. White, as you might suppose, symbolizes the pure and clean. Black, rather than representing a sombre note, indicates a sense of quiet and coming to rest.

These are only the barest outlines of symbolism, and from here both research and expression are up to you.

PAINTING IS WORK

PRACTICE

In every work there comes a moment of question, when it seems that to continue is to head into confusion and destruction—but to stop is to sacrifice what has been done, or at best leave it inept and incomplete.

We have now reached that period of question. You have been given ideas of how to work and what to work with. You have read something of the thinking behind this art in which you are interested. This fabric of observation and appreciation, consideration and application has to be more than simply memorized—it must be made a part of your thinking and working. When you learned to roller skate, you found a new way to balance yourself and another manner of moving your feet. It took not other feet, but the use of another part of your brain, to change your movements. When you work with ink and brushes, you are using and developing new parts of your mind, which require patient practice to be strengthened.

The ideas on creation or symbolism have no real or permanent value to you if you consider them as isolated and unrelated. Expressing yourself through symbolism depends on technique, because your control of your brush enables you to capture a pine tree's sturdiness. To make good strong black ink is a useful skill, but then you must experiment and practice to guide the ink into telling the facts and ideas you want put down. And unless your painting produces something which pleases, why paint?

64

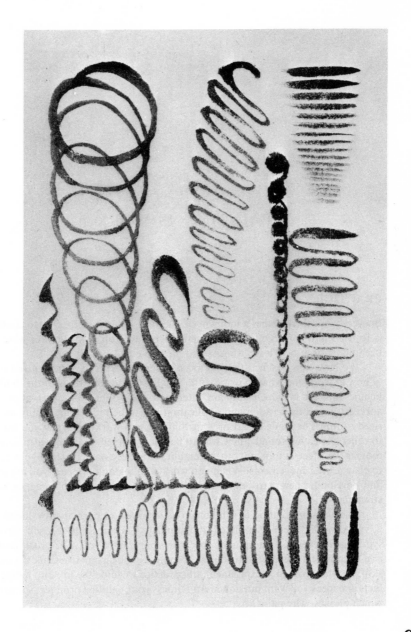

STUDY OF LINES.

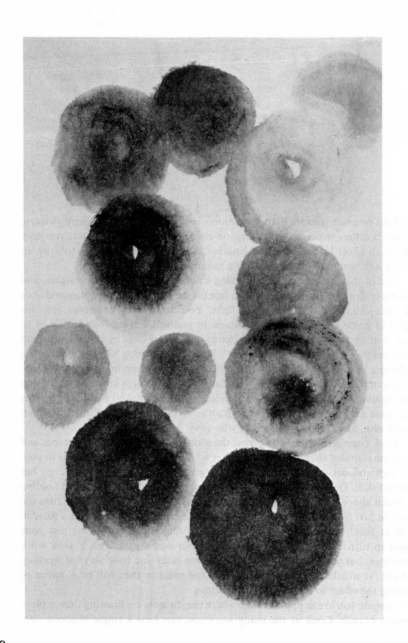

STUDY OF CIRCLES.

Real practice is more than repetition—it is a time for experiment. Because you are a different person from anyone else, and a different painter, you may achieve an effect in one way, and another student may come close to it by an entirely different method. Come into a painting class for a moment.

One of the students has been having trouble with lines, let us imagine, and is trying to draw less stiffly. He tries to free his muscles by drawing lines and lines and lines—straight, twisted, heavy, light. You notice that he moves only his fingers to guide the brush. But you think to yourself, having found it easier to move your wrist, "I find it's much better to make *those* lines by holding my hand above the paper and freeing the brush." Do not try to copy him just because he is taking a lesson and you are working independently. Paint lines your own way. If you can paint such fine lines by holding your whole arm in the air and using your shoulder muscles, you have not failed. On the contrary, you have perhaps discovered a natural skill, or picked up an advanced way of working faster than anyone else, and there will be many who envy you.

Look elsewhere. That lady across the room is drawing a bunch of grapes and forms the rounded shapes by a flick of her whole forearm—or so it seems to you. You sigh and decide you never will paint grapes because you cannot copy her ease and skill. Don't even try to copy. Take a brush with some ink, and holding the brush above the paper with the arm pillowed in your opposite hand, turn the brush in just your fingertips as it touches the paper. A circle—and a shaded circle at that! Draw a thousand circles with fingertips, by moving just your fingers to turn the brush, then by moving your whole arm. This is slow work sometimes, but you will find also that in some cases you have ways of working that are far in advance of other people's, and practice then will be a matter of resisting the effort to race and to skip details.

Imagine you are in another class where the students are drawing from a plum blossom branch. Look at the many ways you can view a single blossom—up,

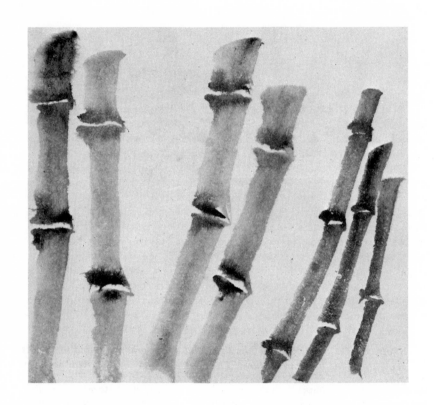

STUDY OF BAMBOO STEMS.

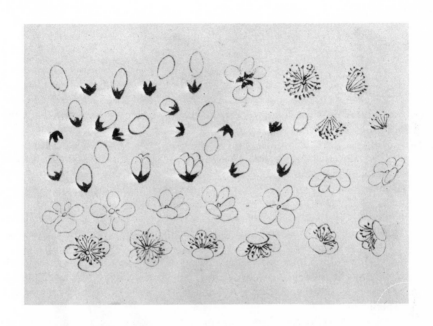

STUDY OF PLUM BLOSSOMS. *The tight bud opens gradually, and the petals separate as the blossom matures. The center is finely drawn, with powdery dots.*

down, face-on, facing away. Some are fully open, some tightly closed. Look at a real branch, or at the illustration on pages 54 and 55, and see how they are in life. With your fingers (or imagination) feel the slight bends in the branch and the places where the buds fit.

But you are at home, and plum blossoms may not be in bloom. Well enough. Take any flower that grows the clustered way the plum blossom does. Draw those flowers and branches in the same way—up, down, front, and back. This is practice: applying your intelligence to perfect your skills, and in your own way.

A while back we talked of patience, of working slowly. The study of bamboo is a whole section of water-ink painting, capitalizing on the ability to paint slowly. The sketches on page 71 show some ways bamboo branches are drawn. Don't copy these because then you will only be drawing a drawing. Go and draw some real bamboo. You will find that the stems are drawn most easily if the longer, older sections are done slowly. The way the brush is turned to use the side edge to achieve the graded tone will come from experiment.

Look at the leaves. If you start them slowly and easily, and then lift your brush with a quick motion but gradually separating its tip from the paper, you will have a good leaf. Again, do not copy the sketch—but go to see bamboo, and find out why some leaves look short, some long, from where you stand.

Last comes the practice of practice. When you have worked well, be sure to go back the next day and see if you can recall your steps: How did you get that shimmer of light? How did you move the brush to make the branch look rough? Was it easier to show the long line of the mountain by turning the brush in your fingers, or by holding the brush firm and moving your arm? This continuing study and retracing of your progress is very important—you learn from your own success; it is the best teacher. If you don't make this effort, you will pick up your brush one day and find that the skill which made yesterday's work so pleasurable has left no more mark than would a lucky accident.

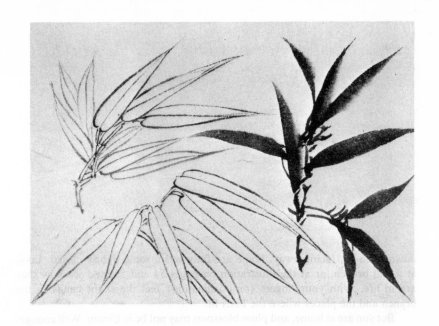

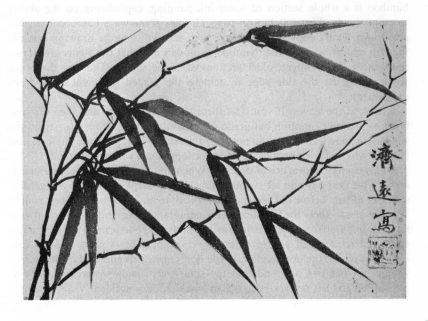

STUDIES OF BAMBOO LEAVES.

71

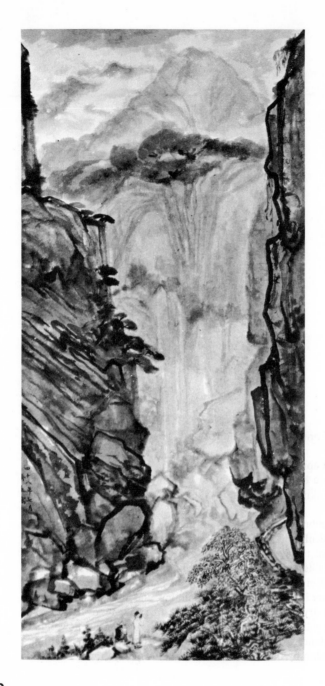

WHITE CLOUDS AND HIGH
MOUNTAINS (*collection Miss
Ruth Martin, New York*).
*Here is a painting of, virtu-
ally, space. The mists hang
like a waterfall between the
mountains, drawing the ob-
server through the narrow
defile to what exists on the
far side.*

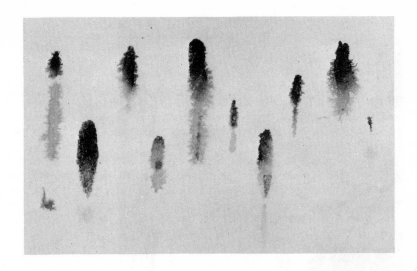

CONTROLLING THE BRUSH.

CONTROL

From your hours of practice comes control—and control is a word difficult to explain.

Control means knowing where and how to stop. When a dancer makes an embracing gesture and brings it to an end at a definite and planned point, she shows control of her skill. Without control she would seem simply to be waving her arms aimlessly.

Controlling your brush means that you must be both brave and cautious, and this is just as difficult as it sounds. The brush cannot talk for you, because it has nothing intelligent to say; it is your conscious and disciplined mind which takes a big brush and fills it with water and a little ink for the edge of a snow bank. So, also, it is control of both your mind and your hand which takes the same brush, puts it in darker ink, goes on with the painting, and at the moment ink is running out uses the dry residue for the trunk of a tree hanging over the snow bank. Control of ink will keep you from putting so dark a center in a flower that the petals lose importance. And it will teach you, fairly soon, that too much ink is just drawn into a blob by the thirst of the paper on which you work.

Control of your technique, the overcoming of the difficulties of a sensitive medium, gradually becomes part of your observation, thinking, and work, and ceases to be a separate consideration, something apart. There's no need to be afraid. If you did not have courage and daring, you would never have begun to work with such a demanding set of instruments.

Take a chance on yourself—paint a tiger lily twice life-size. You may be pleased to find that you can now plan your sketch ahead, and that when you have established the proportions in your visual plan, you can make the ink last to complete an outline which is far larger than those to which you have become accustomed. That is control.

TECHNIQUE

Technique is a misleading and seemingly simple word which acts more or less as a wrapping, a pulling together of the things we have been discussing. It is practice, plus control, plus preparation—added to appreciation and observation. The function of technique is to fit the situation, to match the elements and blend them all within the limits of the goal sought.

Technique starts to function when you think about starting to paint—it establishes the manner of working. Your breath, your muscles, and particularly your hands are at ease and relaxed. You have a subject and it appeals to you for a definite reason—we said before to pick something which pleases you. Here is where you cross the line between painting and simply daubing. You decide why the subject is to be painted. This is not a detached or theoretical decision of form or suitability, but it does set the way in which it will be painted.

Choose, for example, something as prosaic as a teapot. Is it white or black? How black? Shiny like enamel or dull like pottery? Is it blue-black with iridescent shadows or grey-black?

Is it tall? Is it more tall than wide, or less? Will it be tall on a long sheet of paper, or will it seem taller on a sheet placed sideways?

How about the surface of the teapot? If matte, is it just grainy, or merely velvety, or pebbled? It may be shiny, or patterned, or both, but it cannot be fuzzy, and therefore cannot be made to look fuzzy; fuzziness simply would not fit the nature of the object.

Do the sides come down to the bottom directly or is there a flange on which the body of the pot sits? How do you show the flange without giving the effect of a doily or a coaster?

These may seem like many questions, but rest assured you will ask many more when you make your first drawing of that teapot.

74

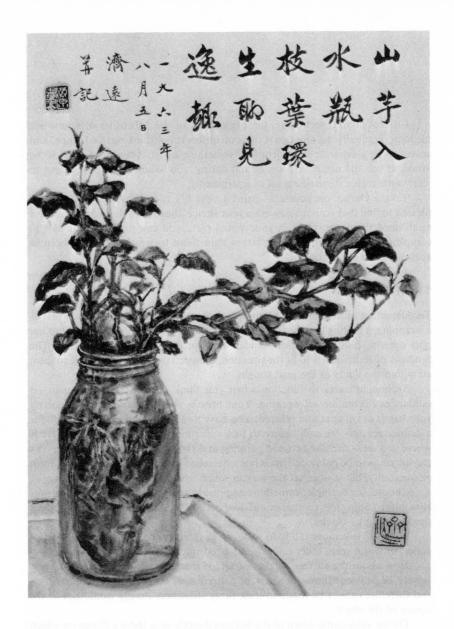

山芋入
水瓶
枝葉環
生耽見
逸趣

一九六三年
八月五日

濟遠
羋記

VINE FROM WATER. *A slip of potato has grown into a vine. This illustration also gives an example of inside-and-outside varying of texture: the outside of the container is shiny and slippery; the inside is not only wet, but filled with the roots of the vine showing through the liquid.*

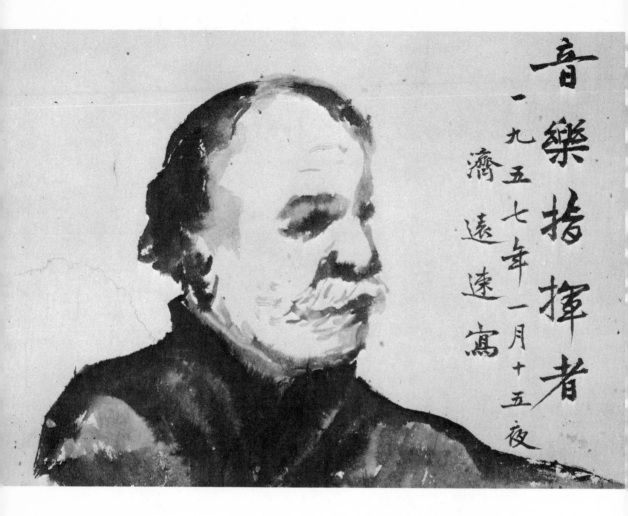

音樂指揮者

一九五七年一月十五夜

濟遠速寫

76

ORCHESTRA CONDUCTOR. *A quick pencil sketch made at Carnegie Hall was the basis for the painting. A free brush conveys the inner sense of quick and effective motion that evokes music just as the brush makes the picture.*

CHOOSING A SUBJECT

Now that you have learned this new way of seeing and observing—weighing, including, excluding—you come to the rather astonishing conclusion that you have too much, not too little, available as subject matter. Now you find all of life —buildings, people, trees, flowers, country roads, and city streets—pressing on your attention, and you are almost overwhelmed by this sudden oversupply.

A child sitting on a park bench is no longer simply himself, but part of a composition of trees, grass, sky. A piece of breakfast fruit is a challenge—how can you show the texture in contrast to a pottery plate, or the colour in relation to other fruit? These small excitements and satisfactions are part of your broadening vision and perception.

The regular turning of the leaves of your calendar is as good a governor as can be found, and it will help you simplify your job of choosing from the apparent flood of subjects. Learn to follow the natural cycles of growing things, from the spare to the full, from the small to the large, from the full bloom to the fading back to a period of rest, quiet and rebirth.

Nature posts no billboards, nor does she publish books about plans or methods. You must watch carefully, for no obvious warning alerts you to the change of leaf colour when the season advances. It may be interesting to take just a single "control" subject— a section of a garden, or corner fruit stand, for that matter. Twice a week make sketches and colour notes of what goes on there. You should know in advance that such a project, carried to the full, would take all your painting time—even in moderation, it will serve as an eye-opener.

All things available can be isolated, identified, and made useful to your brush when you *want* them to be. When you stand in a crowded place watching for a familiar face, you scan all the faces passing by. When the one you await

CORNER OF THE STUDIO WITH STILL LIFE COMPOSITION. *The classic contrast between the rounded shapes of the fruit and basket and the cubic form and square top of the table. Compare the soft firmness of the fruit and the solidity of the table. The inclusion of the studio elements in the background expands the still life to a large picture.*

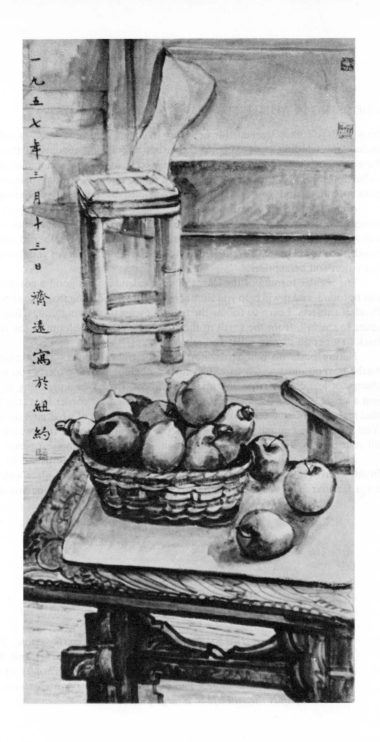

一九五七年三月十三日 濟遠寓於紐約

79

comes in view, knowledge and sense of the oppressing crowd vanish, so un-noticed is it in comparative unimportance now. Your painting subject will appear in much the same way. Look and wait, and you will not be disappointed; some interesting and satisfying subject will come into view, and the clutter of other possibilities will be cut away.

This is no time to limit your future scope by being too specialized. Later, you may find highly selective and demanding interests in landscape or bamboo, peony or cityscapes. For the moment, choose as widely as your main interests take you. There is much to see, and a large part of it will be both pleasurable and practical.

CREATING A PICTURE

It would be gratifying if the mastery of technique alone were the open door to fine, creative painting and satisfactory work, but this is never so. Pictures are always *wholes*—they are not merely composites of paper, plus ink, plus tech-nique. They are entities—complete, finished, and produced as an expression of a personal reaction to a situation or idea.

Technique does enable us to *express* something, to make visible a reaction, or a point of view, or even a rebellious dislike. Mastering our tools and, more than mastering, communicating through their use are accomplishments of a high order. But technique is not a separate problem in art, or in any activity. Tech-nique produces good results only when the painter is able to contribute as an individual, when he creates something entirely his own.

To use these newly developed abilities of drawing and painting to copy Old Masters is no disgrace. It is an honored and honorable method of study, for both

tradition and progress of method may be so learned. For the independent student, to copy is a good way to experiment because in emulating a master he to some extent learns from that master. But to copy as an occupation is to fly in the face of the masters' whole philosophy. The great men and women of every art medium worked from life: they saw, reacted, considered, and initiated. To mimic them is to lose the entire value of what they taught—to overlook their *way* of work is to deny their contribution. To copy outright, or to combine ideas and techniques into a pastiche of composition accomplishes nothing more than does the retyping of an already published book.

From your point of view as a student, you may profit a great deal from studying Chinese or Japanese masters who paint the things you like to paint. No great painters were ever so shallow as to refuse to share; many of them even took on students to see if by some means their talent could be divided—but it never was. Go and study the landscapes; see how the Northern Chinese painted trees and mountains. Study how they made horses so sturdy. Horses were a part of their life and an important part of their economy; they knew a great deal about them. You may discover paintings that teach you much about the equine model, but think of the paintings in relation to a horse you can go to see and sketch. Go back to your brush and ink without the other pictures being nearby.

You may see horses in terms of sturdy backs or long, racing legs. These are your responses to the living quality of the animals; by pursuing your own way you will be free of the danger of squeezing your personal art into the rigid mold of painting in the past tense. Now you are following the route that men of the fourth or fifth century laid out—the open route that carries pleasure and progress from generation to generation. This is the way both to preserve tradition and to create new tradition.

FISHERMAN'S HOME, MACAO (collection Mr. and Mrs. Albert R. Kahn). The humble home and the small figures in their boats present a simple and softly poetic vista. Water separates the distant mountains, the boat, and the dock. The lightest touch keeps the space from emptiness; simple and few lines indicate a wide expanse of water. Broad brush strokes make distant, misty mountains.

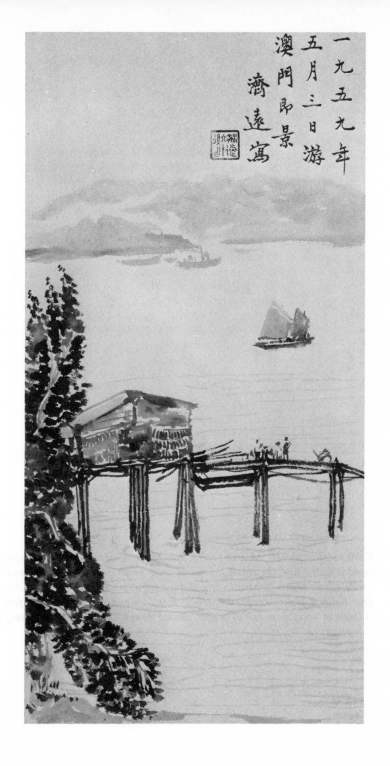

一九五九年
五月三日游
澳門昂景
濟遠寫

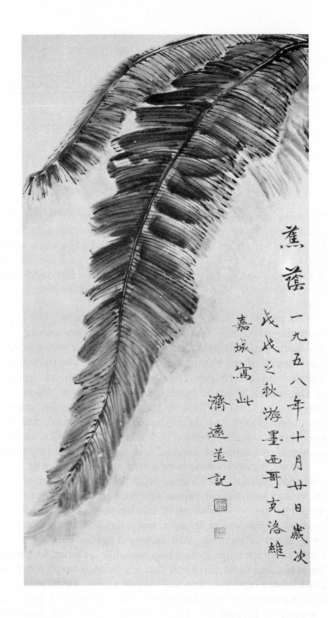

蕉蔭 一九五八年十月廿日歲次

戊戌之秋游墨西哥克洛維

嘉城寓此

濟遠並記

BANANA LEAVES. *The relationship of calligraphy and drawing is extremely clear. Compare the beginnings and ends of strokes in the spines of the leaves with the complete calligraphic script.*

SIMILARITY AND DIFFERENCE

A VERY SPECIAL CONTRIBUTION

Water-ink painting has evolved from early Chinese writing, from calligraphy. In all the paintings, you can trace the strokes which echo those of the written forms. Conversely, in those written forms, and particularly in the older kinds of writing which go back 3,000 years and more, you can find the simplified outlines of the object—an early symbol for "fish" is like a fish, very clearly, and even the present form for "door" shows the uprights of the frame with the suspended panels.

You probably do not know Chinese calligraphy, but if you take time to study the examples you come across, you may learn some useful things about line-work that will help you define your forms and compositions. Look at the painting of the banana leaves on page 84: the short strokes showing the leaf divisions clearly echo the similar strokes in the calligraphy of the poetry.

The unique place of water-ink painting in the whole world of painting may be compared, perhaps, to the link between ballet and music. Almost as the choreography and the movements of foot, hand, and body carry music over into physical expression of a mood or experience, so the techniques and materials of brushwork demand a very special level of physical involvement.

Western painters work with sturdy brushes, with paper and canvas of firmness and resilience. The Oriental brush and paper are soft and gentle (and to the uninitiated seem almost infuriatingly so, sometimes). Because of these qualities, special senses or extensions of existing sense begin to develop. There is no restraint of freedom or thought, but a quickened response and reaction to the physical act of painting. You develop a special delicacy of feeling. When the brush meets the paper (which may seem like a blotter, so quickly does it absorb the water and tone) you know that too heavy a touch will produce a blob and not a branch, and your arm will lift just a little. Again, with a dry brush, it may seem necessary to twist the brush with a curve, and your body begins automatically to prepare for this new motion, even while your eye calculates just where it is to be.

In such brief moments of perception you develop this whole absorption of yourself into your painting. There is no talk of splash and splatter or of freeing

your emotions in a squiggle. You are already reaching to extend a long line of lotus stem, or you are practically tiptoeing with your hand to put the powder-tiny centers on an anemone.

These are the things no one can teach; these are the visible expressions of the depths of emotion and vision which lie within you, waiting for the key, for the rhythm and balance of demand of these special tools.

WIDENING YOUR VIEW

Most adults who begin to paint have already been schooled in the work of the Western masters. The names of Leonardo, Michelangelo, and Rembrandt, of Corot and Reynolds are familiar even in the daily press. To follow, even in an elementary way, is to be in a clearly marked path.

Westerners are much less aware of the history and scope of Oriental art. Although these painting arts go far back in time, the great mass of work is much less known, much less shown. Of the books that have been written in the past, and of those that are fortunately now coming into print, even the best must be read with care. Much of the writing may seem hard to follow, for Westerners never will see the old Chinese and Japanese masters as do the Oriental mind and eye. To be honest—how can they?

Further, interpretation is a highly personal activity. Some of the best writers are not always skilled interpreters, and sometimes the most skilled interpreters study and analyze paintings without really liking them. You have to read, digest, search, compare—and then choose what you like and what seems good after study.

Most small museums have some examples and there are collections of great merit in the larger ones: the Freer Gallery (Washington, D.C.), Boston Museum of Fine Arts, Metropolitan Museum (New York), Cleveland Museum, and the Art Institute of Chicago, to name a few.

If you start with one period and study it for a while, you may avoid confusion. You will discover, for example, that in the Sung Dynasty there existed an Academy of Painting. This was a particularly rich and productive time because the Emperor was himself an accomplished and serious artist; all the painters followed his desire to study and learn from nature, to start with important and living elements, rather than occupy themselves with the minor areas of decoration or simple space elaboration.

In your study, you may begin to see in other periods of painting, for example, in some works from the late Ming Dynasty, where the great creative surge stopped. The impetus and the spirit became sidetracked. The painters turned

江渚蘆荻空
泊舟
一九六三年十一
月十日溥　寫

IN THE REEDS NEAR THE HUDSON RIVER. *Empty and solitary rowboats are fastened among the reeds near the river, and the sky and grasses edging the creek are reflected in the water; the reeds move in the wind. The picture has an autumn feeling.*

87

YOUNG GIRL—TWO SKETCHES. *A very simple line depicts a clearly Oriental
face. The whole contour from brow to jaw is one line—the front of the
head clearly separate from the back.*

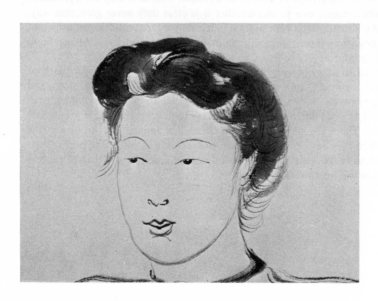

themselves into technical copyists to be sure they were doing the right things; they repeated, copied, or used old paintings as a basis for new. They painted the paintings—and they stopped painting life itself. You can identify the repetitive elements—flowers and groups of leaves, for example, look as if they were produced from a rubber stamp, one so like another it is clear they never grew that way. Hands lose character and begin to look like little patches with fringes instead of fingers. Recognizing these things will not make you an authority, but it can build your belief in your ability to learn, to see, to know, and to do well.

It is hard to find contemporary Oriental painters exhibiting—for much of the emphasis for many years was laid in emulating Western ideas, methods, and styles. In a way, you are working with unknown and unseen collaborators, each working back in your different worlds and ways to find, revive, and enjoy ancient satisfactions. There are many painters in China and Japan, and throughout the lands to which they have gone to live, who are learning as you are to pursue their own individuality through observation and patient practice, and then to express themselves in ink brushwork.

EAST AND WEST

Every person, every country, has its own flavor, its own character. We talk, eat, dress, write differently, each in our own way, and most of us in the way in which we were brought up, but we all talk, eat, dress, and write. Some of us spring from warrior peoples, some from men of peace. Other differences are less clear, but we know that in all places, in all centuries, there have been selfish men and generous; there have been individualists and men of the group.

As we explore these seeming divisions, there come vague recognitions to those who perhaps taste an exotic food and find it surprisingly familiar. Many a wandering person has found a place across the globe which seemed homelike in a way that geography and ancestry would deny. These intangible but strong links into alien worlds have yet to be explained to the satisfaction of the scientists, though some of us understand without lengthy explanation.

Artists, whatever their medium, have a rather special bond, for music, painting, sculpture have all sprung from the hearts of men—and humanity is the fabric of the living. Art is as much part of man as the hunger that is assuaged by food, whether pressed duck or seal fat. It is as quickening as the warmth that comes from tropical sun or the burning of peat when one is cold.

Just as one American painter may be known for his paintings portraying city life, a North Chinese may be known for his horses and his mountains. As the Italian painted the rich reds and the jewels of the Doges, the South Chinese

left evident for all time his delight in his long-tailed fish and the lotus which abounded in his beautiful water-rich land. To each was given a sense of participation in his life, and from each came the response.

It is from these individuals that truth and understanding come. The Chinese who paints a single melon so completely that it needs nothing else to fulfill its task as a whole composition is more closely akin to the French or Italian painter who sees the same sun shining on a pear or grapes than he is to his own countryman who takes no pleasure in painting or good fruit. His own brother, also a painter, may feel himself part of the noisy business of living, recognizing the forever lively and changing crowd that delighted the Dutch and Flemish painters of festivities.

These are the skeins of friendship, across which are woven the cultivated response of art and people. These are the similarities which, if given freedom and a little encouragement, grow into a structure of friendship that differences of language or color of skin cannot damage.

To have preferences is a part of being human. To know why you have these personal likes is part of being educated, and to seek and discover other new and strange things that please and enrich you, as well as other people who understand and respond to your pleasures, is your responsibility as someone who paints today.

You may be one of those with the opportunity to explore, for in picking up this book on Oriental Brushwork, you have already demonstrated that you seek something beyond the tools of the world in which you were born, and to which you may feel at times almost an utter stranger.

Simply to mix, to moderate the heights which national or personal talents exhibit would be to create a mongrel civilization with no glory of its own. But to abandon the small-minded persistence of those who cling to differences and seek to set them always in opposition, to turn to the larger thinking in which each form of expression may be different, but never divided from those to which it has similarities of spirit, is to create for yourself and others a whole sphere of comprehension that fashions differences into complements instead of dividers, as do light and dark together make a whole day, and water and land a world.

STORM KING (*collection Mr. and Mrs. Kenneth Carroad*). *From the sheer heights of the mountainside, the very sharp drop makes possible a clear sight both of the long vista and of the many small islands scattered at the foot of the home of the bringer of the storms. The foreground trees are drawn clearly against the tone of the rocks from which they spring, and aid in showing the distance from the middle island and far shore by contrast.*

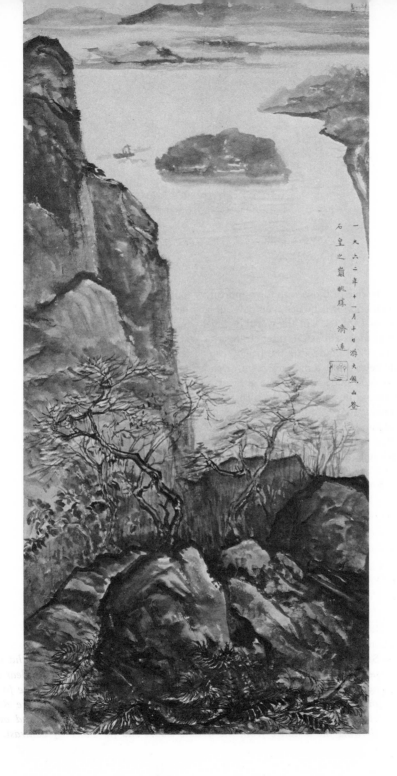

一九六二年十一月十日游大鲍山登石皇之巅眺珠济达

93

ABOUT THE AUTHOR

Wang Chi-Yuan was born in China in 1895. After establishing himself as a painter, he headed the Faculty for Western Painting at the Shanghai College of Fine Arts. He also drafted texts for the Ministry of Education and published his own books on painting.

He has traveled widely throughout Europe and the Far East, and exhibited his paintings in many parts of the world. During the war in China he worked in devastated areas, and contributed the money raised from exhibits of his paintings to the China Distress Relief Committee.

Wang Chi-Yuan has been living in the United States since 1941, first on the West Coast and then in New York, where he established the School of Chinese Brushwork. He teaches with the materials of Chinese water-ink painting and calligraphy because they are satisfying for the expression of Western thought.

His work has been seen in private and museum collections, including the Metropolitan Museum in New York, the City Art Museum in St. Louis, the Chicago Art Institute, the Montreal Museum, the National Historical Museum in Taiwan, and the Museo Nacional de Arte Moderno in Mexico.

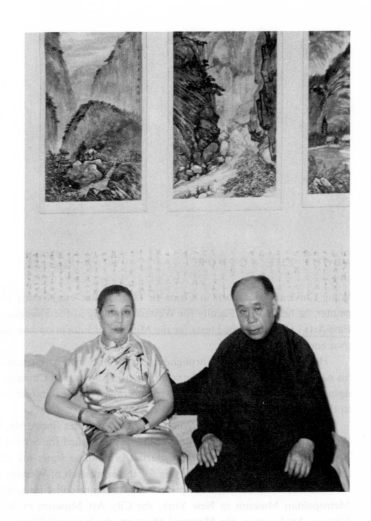

PROFESSOR AND MADAM WANG CHI-YUAN.